Untitled (21 Days of Bloodwork — Steady Decline), 1994
Graphite and wash on paper
21 drawings, each 15 x 11 inches

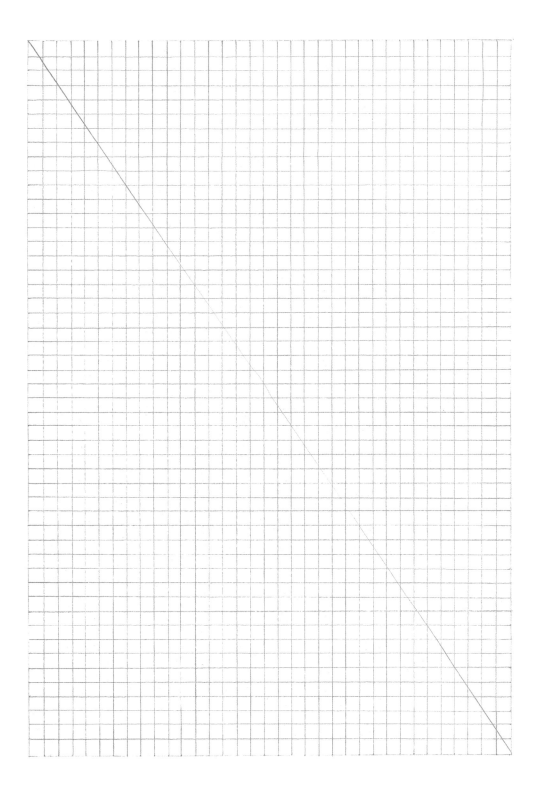

Hirshhorn Museum and Sculpture Garden,
Smithsonian Institution, Washington, D.C.

The Museum of Contemporary Art, Los Angeles

The Renaissance Society at The University of Chicago

Felix Gonzalez-Torres

Contents

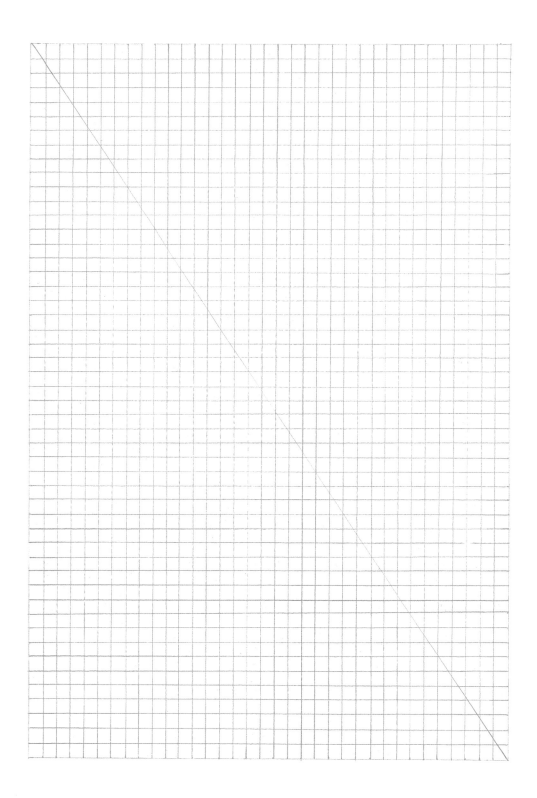

Preface and Acknowledgments

In presenting this exhibition of the work of Felix Gonzalez-Torres, the Hirshhorn Museum and Sculpture Garden in Washington D. C., The Museum of Contemporary Art in Los Angeles, and The Renaissance Society at The University of Chicago join forces. Over the last twenty years our institutions have often shared parallel concerns in our programs as we investigate work which explores the linguistic basis of meaning, the context of site, and the body's relationship to the object and space. Now, as we approach the turn of the twenty-first century, we find the work of Felix Gonzalez-Torres, which puts forth a new vision in its critique of earlier Conceptual and Minimalist concerns while bringing to the dialogue issues referencing gender and sexuality, death and loss, time and change, freedom and repression. Using a clear and reduced vocabulary to address such profound human concerns, he moves to the forefront of his generation.

The hallmark of Felix's work is its directness, simplicity, and the involvement of the viewer. In removing a sheet of paper from a stack, taking a piece of candy from a corner spill, or stopping to consider the associations of a date such as 1969, meaning is created in the act of participation. Individual action is vital to the work's completion. In the same way that the stacks are unending, so too is the work's reference, as meaning shifts from viewer to viewer. Felix has given us the freedom to complete his work

through the memories we bring to each piece, and as with every freedom there is a corresponding responsibility. The events of the latter half of the twentieth century, and in particular the last decade, have made us aware that our freedoms are threatened by the erasure of memory. Perhaps Felix's greatest gift is his invitation to remember, and our obligation to act.

This project is made possible in part through the generous support of Lannan Foundation. Their openness has allowed three institutions the freedom to pursue separate exhibitions while collaborating on a single publication. Their generosity and careful consideration sustains life, growth and exploration within our museums, and we remain grateful.

At The Museum of Contemporary Art, Los Angeles, the exhibition is presented as part of MOCA's Focus Series, and has been supported by the MOCA Curators' Council. Billboard space has been provided by Gannett Outdoor. The Focus Series is made possible in part by a grant from the Pasadena Art Alliance. At The Renaissance Society, the exhibition has been sponsored by the Illinois Arts Council, a state agency; the City Arts Program of the Chicago Department of Cultural Affairs, a municipal agency; and by the membership. Indirect support has been received from the Institute of Museum Services, a federal agency offering general operating support to the nation's museums. The catalogue received the continued commitment of the Elizabeth Firestone Graham Foundation.

This special collaboration has been possible due to the generous cooperation of the three institutions. Our special gratitude goes to Hirshhorn Museum Director James T. Demetrion and MOCA Director Richard Koshalek for their unending support and encouragement of this unusual project. In addition, Hirshhorn Museum Chief Curator Neal Benezra and MOCA Chief Curator Paul Schimmel offered much-appreciated enthusiasm and guidance.

At each venue, the exhibition has been realized through the collective efforts of individuals in all departments. At the Hirshhorn thanks go to Barbara Freund, Registrar; Ed Schiesser and Bob Allen of the Exhibits Department; Public Affairs Officer Sidney Lawrence and his assistant

Michelle Colburn; Editor Kathy Preciado; Francie Woltz; Tina Gomez; Kathy Watt; and Vijay Moses.

At The Museum of Contemporary Art, our thanks go to Kathleen Bartels, Director of Administration; Director of Development Erica Clark and Grants Manager June Scott; Chief Financial Officer Jack Wiant; Exhibition Production Manager John Bowsher, Chief Preparator Eric Magnuson and Preparators Jose Marin and Jang Park; Chief Registrar Mo Shannon; Curatorial Assistant Stacia Payne; Assistant Director of Communications Sylvia Hohri and Press Officer Dawn Setzer; Director of Education Vas Prabhu and the entire Education Department.

At The Renaissance Society, thanks are extended to Randolph Alexander, Development Director; Joseph Scanlan, Assistant Director and Director of Education; Karen Reimer, Registrar and Preparator; Patricia Scott, Bookkeeper and Secretary; and Loius Brandt, Farida Doctor and Lisa Meyerowitz, Gallery Assistants.

We are particularly indebted to Andrea Rosen and Michelle Reyes of Andrea Rosen Gallery, New York, for their tireless patience and generous assistance with the myriad details of the exhibition's organization. Thanks are also due to Margo Leavin Gallery, Los Angeles, for additional help and encouragement.

We also wish to thank MOCA Editor Russell Ferguson and Assistant Editors Sherri Schottlaender and John Alan Farmer, along with designers John Campbell and Pamela Racs, for their careful work on this publication.

Finally, our deepest gratitude goes to Felix Gonzalez-Torres for the pleasure and inspiration his work continues to give us.

Amada Cruz, Associate Curator
Hirshhorn Museum and Sculpture Garden,
 Smithsonian Institution, Washington, D.C.

Ann Goldstein, Curator
The Museum of Contemporary Art, Los Angeles

Susanne Ghez, Director
The Renaissance Society at The University of Chicago

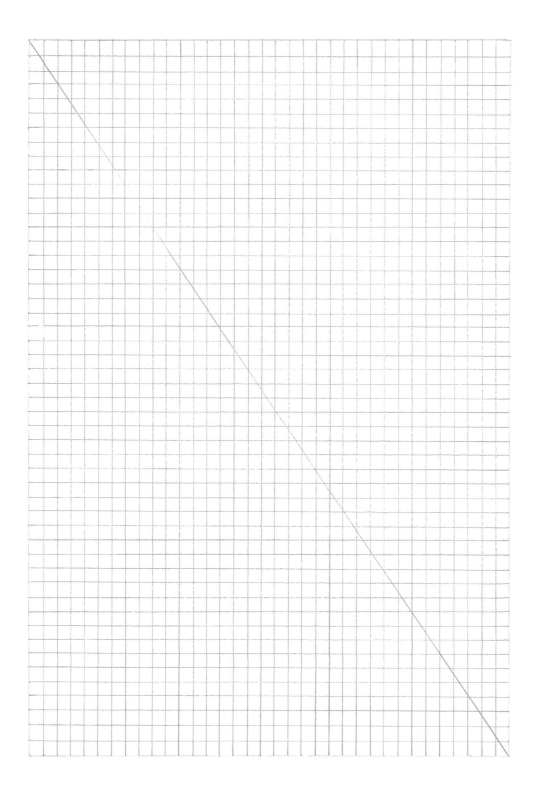

The Means of Pleasure

Amada Cruz

In an October 1993 lecture, Felix Gonzalez-Torres limited his remarks to the dispassionate recitation of a protracted inventory of statistics about worsening social conditions during the years of the Reagan and Bush administrations. He delivered this performance against the backdrop of a projected formal portrait of the flamboyantly wealthy family from the 1980s television series *Dynasty*. Each time Gonzalez-Torres changed the slide, the same image reappeared as if it were stuck in the projector, a stubborn picture that would not go away. It was a fine example of Bertolt Brecht's theory of Epic Theater.

Brecht (1898-1956) developed the concept of Epic Theater throughout his career. As a Marxist writing in the aftermath of World War I, through Nazi rule, and after World War II, Brecht advocated a politically committed theater that would respond to the social conditions of the time. In a 1930 essay, "The Modern Theater is the Epic Theater," he contrasted the narrative Epic Theater with the Dramatic Theater. Epic Theater turns the spectator into an active, thinking observer rather than a passive receptor carried away by the plot into escapist empathy. The goal of Epic Theater

is to stimulate the viewer to make a decision on what is presented and to motivate action.[1] To this end, Brecht proposed distancing strategies that would emphasize the artifice of the theater, including requiring actors to address the audience directly, inserting songs, choruses, and rhymes in plays, and using text as part of stage sets.

Gonzalez-Torres has acknowledged the importance of Brecht's writings to his own working method. The formal restraint of his work parallels Brecht's austere style of presentation and forces the viewer (initially at least) to approach his works on an intellectual level. Yet the practice of concealing radical content under an acceptable, even beautiful, veneer is as central to Gonzalez-Torres's strategy as it was for Brecht.

The goal of empowering the audience is foremost in Gonzalez-Torres's mind, as his work provides only clues and gaps that encourage viewers to construct meaning. His is an art of blank spaces and things left unsaid. In the stacks of prints in endless editions that contain text, isolated phrases such as "Nowhere better than this place" and "Somewhere better than this place," or paragraphs from newspaper articles, exist incomplete on sheets of paper. The series of 'portraits' are lists of important dates and events in the particular 'sitter's' life to which other viewers bring their own memories. The blank areas above the running text in many of these portraits and in the stacks in which the sheets have only an evocative color, such as the red *Untitled (National Front)* (1992), demand signification. In the recent works made of single or multiple strings of light, whoever exhibits one can install it at will. His titles are only hints, often *Untitled* with the most revealing information following in parentheses.

Along with the intellectually active relationship viewers have with his work is a physical engagement that confronts the conventions of how an artwork functions. Gonzalez-Torres's formal strategies are intricately tied to the content of his work. In *Untitled (Welcome)* (1991), viewers must lift the neatly piled rubber welcome mats to find the photographs and mementos hidden underneath. The authoritarian, Minimalist forms he employs in this work,

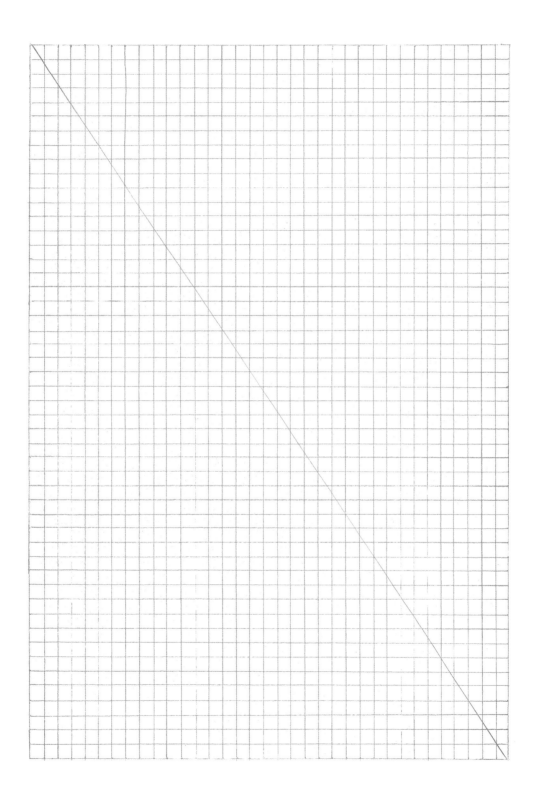

as well as the stacks and carpet-like candy installations, function as decoys for vulnerable works that disappear as each viewer takes a sheet or a piece of candy. To eliminate these works is to complete them, and yet they are endlessly reproducible. What is original is not unique; a sculpture is an edition of prints; an installation is ingestible. Gonzalez-Torres relates this formal deception to his homosexual orientation and the idea of 'straight-acting'— of appearing to be 'normal' but actually being the 'other.'[2] Onto the clean, apparently neutral, veneer of his essential forms, he adds complex life issues relating to gender, sexuality, love, and mortality. Thus, what appears to be a 1960s beaded curtain is *Untitled (Chemo)* (1991), and a work that consists of thirty-one small grid paintings hung in a row is *Untitled (31 Days of Bloodwork)* (1991). In the age of AIDS these titles take on ominous connotations.

The dispersal of information is an important aspect of Gonzalez-Torres's work, most obviously in the stacks and the public billboards he has produced. In Brecht's play *Galileo*, the astronomer and physicist who proved the Copernican theory that the earth revolved around the sun publishes his radical studies in the vernacular Italian rather than Latin, in order to spread the potentially liberating news more widely. Gonzalez-Torres similarly wants his work to exist beyond the art world. Aligned with this purpose is what Susan Tallman has referred to as "the element of commercial subversion" in his work.[3] The owner of a stack or candy installation shares it with a voracious public, particularly when the works are exhibited in a public space, and the buyer of a billboard acquires only the right to refabricate it and install it outside. Gonzalez-Torres is also planning future works that will circulate publicly in the form of advertisements for local museums in ethnic neighborhood newspapers (in their respective languages), and as installations of strings of lights along public streets.

Brecht believed that writers should use various 'cunning' means in order to distribute information. In "Telling the Truth: Five Difficulties," an essay that has appeared as the appendix to *Galileo*, he describes the obstacles that writers encounter when trying to spread their ideas in a hostile environ-

ment. He lists Confucius, Lenin, Lucretius, and Shakespeare as examples of writers who have used metaphor, allusion, and beauty as shrewd devices to spread a social message.[4] Brecht himself used music, song, and humor to communicate with audiences and proposed that "the use of opera as a means of pleasure must have provocative effects today."[5]

Like Brecht, Gonzalez-Torres uses both didactic and pleasurable devices in his work. In *Untitled (Death by Gun)* (1990), a stack of prints that lists all the gun victims in the United States during a one-week period, he is perhaps at his most didactic. *Untitled (Placebo)* (1991) is an example of a work that is provocatively pleasurable. The glistening, silver-wrapped sweets beckon viewers to take a piece, but the satisfaction is fleeting, like a fake pill or an unfulfilled promise.

Gonzalez-Torres believes unabashedly in using beauty, that recently discredited aspect of art, for political ends. He believes that "aesthetics *is* politics . . . a set of cultural and social values. . . . The problem with political art is that it had a look which was too easy to dismiss. We should rescue beauty and pleasure." He thus wants to "repossess beauty for our own ends and reinterpret it for our own purposes."

A strong romantic impulse runs throughout Gonzalez-Torres's oeuvre, and the most beautiful of his works have a wistful, melancholy quality. *Untitled (Alice B. Toklas and Gertrude Stein's Grave, Paris)* (1992) is a photograph of the flowers at the grave of the famous lesbian couple. Two long, diaphanous curtains of pale blue fabric that hang and gently move across a window is *Untitled (Blue Curtains)* (1989-91). The most personally emotional imagery has paradoxically appeared in his most public works, the billboards. *Untitled* (1991) is a black-and-white photograph in soft focus of an unmade empty bed

Untitled, 1991

with the indentations of two bodies apparent. Installed throughout New York City, this intimate image raises the issue of public scrutiny of private behavior and also functions as a memorial for those who had once lain there. The recent series of billboards with images of birds in flight depict one or two coupled birds that appear small and adrift in an immense, cloudy, sometimes stormy, sky.

There is a sense of absence and mourning in these beautiful, foreboding images — the melancholia that the linguist Julia Kristeva eloquently describes as a "sad voluptuousness, a despondent intoxication. . . ."[6] In her essay, "Beauty: The Depressive's Other Realm," she asks:

> Can the beautiful be sad? Is beauty inseparable from the ephemeral and hence from mourning? Or else is the beautiful object the one that tirelessly returns following destructions and wars in order to bear witness that there is survival after death, that immortality is possible?[7]

Kristeva posits the beautiful object as a healing mechanism, an "Artifice . . . [that] replaces the ephemeral . . . beauty emerges as the admirable face of loss, transforming it in order to make it live."[8] The ephemeral or fleeting sense of time recurs throughout Gonzalez-Torres's oeuvre, a poignant example being *Untitled (Perfect Lovers)* (1987-90), a work that consists of two identical, generic wall clocks that have been set at the same hour. Inevitably and imperfectly, one will cease working before the other. In *Untitled (Orpheus, Twice)* (1991), twin vertical mirrors hang to the floor, side by side, and allude to the Greek myth of Orpheus, who descended into the Underworld to rescue his love, Eurydice. The one condition for her release was that he not look back at her until they

Untitled (Perfect Lovers), 1987-90

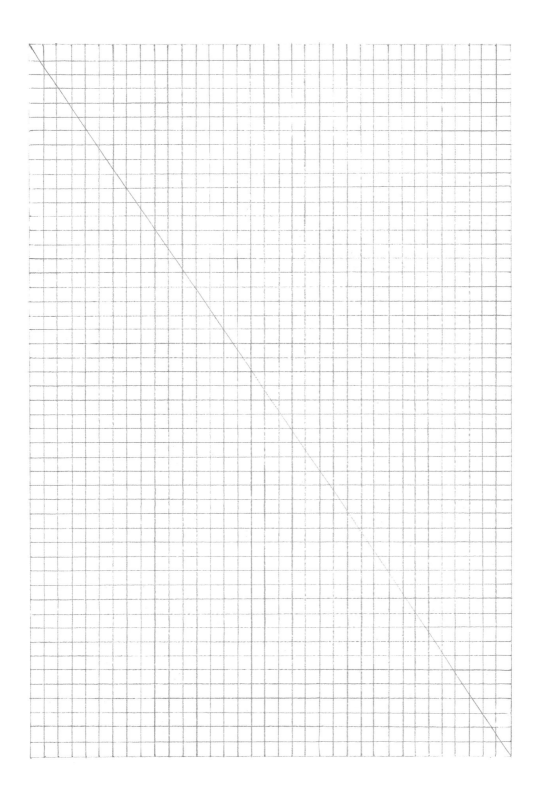

were free, but Orpheus succumbed to the temptation and lost her forever.

The conflation of the private and public realms is an area of much interest in recent art, and Gonzalez-Torres shares this concern. Writing about the relationship between the private and public in the work of the French writer Marguerite Duras, Kristeva states:

> Political events, outrageous and monstrous as they might be . . . are assimilated to the extent of being measured only by the human suffering they cause . . . the mocked private domain gains a solemn dignity that depreciates the public domain. . . . As a result, public life becomes seriously severed from reality whereas private life, on the other hand, is emphasized to the point of filling the whole of the real and invalidating any other concern.[9]

Political events gain meaning only as they affect individual lives. The threat of Galileo's theories was not simply a matter of cosmic speculation but a challenge to the authority of the Catholic church and the feudal social structure of the time. As a monk tells the astronomer, his theories would rob his peasant parents of their comforting belief that they continually work the land as part of a higher order. "'There is no eye watching over us after all,' they would say. . . . 'Nobody has planned a part for us beyond this wretched one on a worthless star.'"[10]

Untitled (Go-Go Dancing Platform), 1991

As a gay man, Gonzalez-Torres knows that public policy can have an immediate impact on his private life. The vulnerable body, where politics crystallizes for one whose marginal status is determined by what he does with it, is alluded to in several series. The earliest candy piles were based on a particular per-

son's weight. The constant depletion and rejuvenation of these and the stacks give them a life of their own, as does the replacement of the extinguished light bulbs in the light strings. The literal body makes an appearance in *Untitled (Go-Go Dancing Platform)* (1991), a white platform with a rim of lights that was occasionally enlivened by a well-muscled male dancer listening privately to a walkman. A dancing couple has also performed under a canopy of light strings, again involved in their own music by virtue of a walkman with double earphones.

The light strings contain numerous references — light as a haven, a symbol of enlightenment or spirituality, and a source of warmth, yet as impermanent as the unenduring bulbs. Depending on how the viewer installs them, hanging from the ceiling, for instance, or outside, they can create a festival ambiance, or, lying on the floor, they can appear dejected, just a set of bare bulbs. *Untitled (North)* (1993) is perhaps Gonzalez-Torres's most optimistic installation, comprised of twelve strings of lights. The piece alludes to the Cuban habit of referring to any place north of Miami as *el norte*, and to the idea of such a place as one of aspiration. He has also thought of creating an outdoor installation of numerous lights and titling it *America*, which remains, to the immigrant that he is, a mythical place of fragile hope that must be maintained.

Untitled (North), 1993

Brecht's goal was "to develop the means of pleasure into an object of instruction, and to convert certain institutions from places of entertainment into organs of mass communication."[11] Finding inspiration for his own work in the playwright's theories of a political theater, Gonzalez-Torres makes use of seductive forms and methods of public address to force viewers into a complicity with him in questioning established conventions

and creating new meaning. Inspired by everyday events, personal biography, and the challenges of late twentieth-century life, Gonzalez-Torres's intent is to move viewers to a "place of beauty, freedom, pleasure."

[1] Bertolt Brecht, "The Modern Theater is the Epic Theater," in *Brecht on Theater* (New York: Hill and Wang, 1964), p. 37.

[2] All otherwise unattributed quotes are from a December 8, 1993 conversation with the artist.

[3] Susan Tallman, "The Ethos of the Edition: The Stacks of Felix Gonzalez-Torres," *Arts Magazine* 66, no. 1 (September 1991): 14.

[4] I am indebted to Tim Rollins for pointing out this essay to me.

[5] *Brecht on Theater*, p. 36.

[6] Julia Kristeva, *Black Sun: Depression and Melancholia* (New York: Columbia University Press, 1989), p. 5.

[7] Ibid., pp. 97-98.

[8] Ibid., p. 99.

[9] Ibid., p. 235.

[10] Brecht, *Galileo* (1940) (New York: Grove Press, Inc., 1981), p. 84.

[11] *Brecht on Theater*, p. 42.

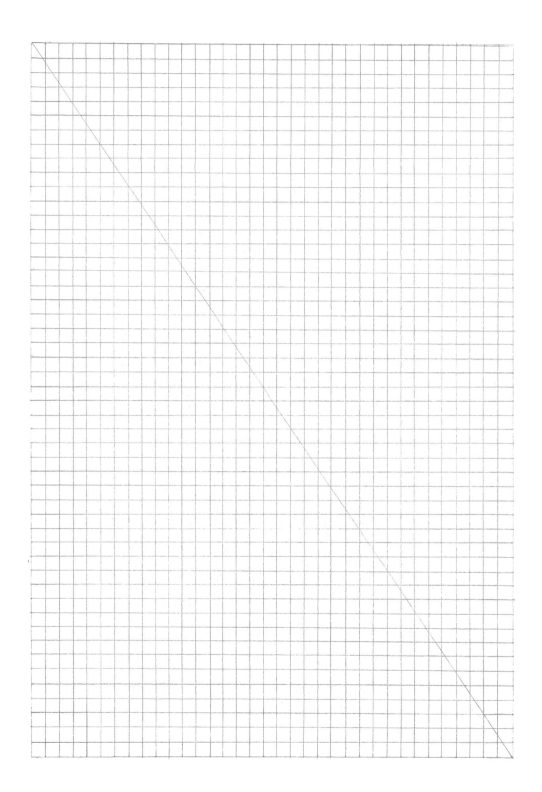

The Past Recaptured

Russell Ferguson

One of the most important things that Felix Gonzalez-Torres accomplishes in his work is the clearing of a meaningful space in the present for memories of the past. He shapes memories — his and ours — into works of art that offer not only the pleasures and consolations of reflection, but also the possibility of transforming the present. He uses individual memory as a tool to counter the artificial separation of the 'personal' and the 'public,' a distinction that works in practice to delegitimatize whole categories of lived experience. And he uses it to work against the processes of suppression and exclusion through which the powerful write the story of the past. Gonzalez-Torres recognizes memory as fragmented and uncontrollable, and that these qualities in no way diminish its power. On the contrary, the most intimately personal and unstructured series of recollections has within it the capacity to disrupt apparently much more powerful public histories, and to bring forth alternatives. In looking back, we find the resources to change the present, and thus to help create the future.

As Gonzalez-Torres has said, "We have an *explosion* of information, but an *implosion* of meaning."[1] In Walter Benjamin's terms,

The replacement of the older narration by information, of information by sensation, reflects the increasing atrophy of experience. In turn, there is a contrast between all these forms and the story, which is one of the oldest forms of communication. It is not the object of the story to convey a happening *per se*, which is the purpose of information; rather, it embeds it in the life of the storyteller in order to pass it on as experience to those listening. It thus bears the marks of the story-teller much as the earthen vessel bears the marks of the potter's hand.[2]

Throughout Gonzalez-Torres's work it is possible to see his struggle with the information explosion, and his attempts to reshape this huge mass of material through its relationship with his own lived experience. He seeks, that is, to leave the mark of his hand on it, and thus to convert it from information into story; to give information meaning, and to rescue it from atrophy.

A recent work by Gonzalez-Torres, *Untitled (Album)* (1992) is simply a photo album. Purchase of this piece is, however, only a step towards its completion, because it is incumbent on the owner to continue the process by filling the album with his or her own photographs. While the album form does suggest a kind of narrative closure, the narrative will be different in each version of the work. It also remains open to revision at any time, just as the subjects of Gonzalez-Torres's date line portraits remain free to add to or delete from the list that provisionally represents them. *Untitled (Album)*

Untitled (Album), 1992

expresses in the most direct way two themes central to Gonzalez-Torres's art: the importance of personal memory, and the invitation to the work's viewers to participate in the construction of its meaning.

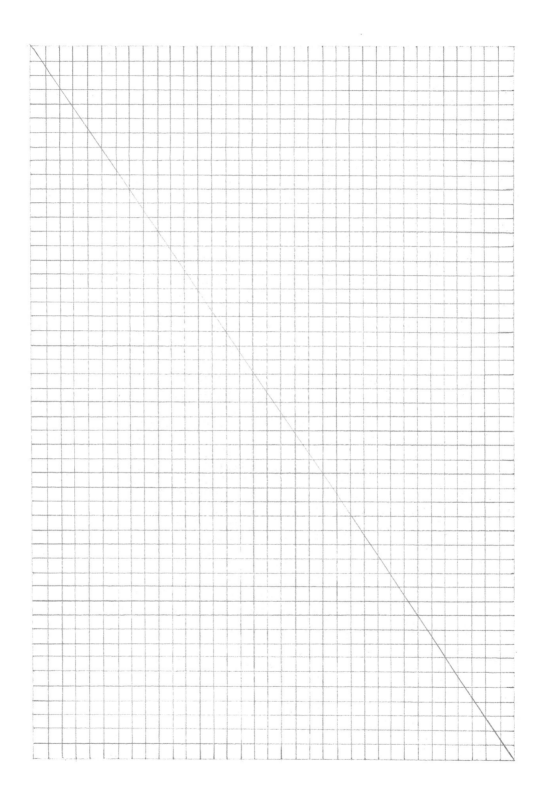

The relatively little that we really remember of our lives is only the visible summit of an iceberg of forgotten feelings and events. Here and there jagged peaks break through a surface that continues to freeze over. Gonzalez-Torres is constantly aware of this structuring absence. Even the form of his titles — always *Untitled*, followed by a parenthetical (and thus conditional) identifier — acknowledges that we are offered not an autonomous object complete in itself, but only a fragment taken from a life that continues outside our temporary relation-ship with it as a viewer, a life that cannot be separated from the context in which it is lived, and that will always spill over any boundaries we might try to draw around it. All the work is therefore in a sense one work, *Untitled*, a work that can never be complete. By constantly moving back and forth, pausing at different points of remembered experience, Gonzalez-Torres avoids the sentimentality that could so easily accumulate around a more directly autobiographical project. He offers instead a constantly changing series of potential readings, always surrounded by a wide open space which the viewer is invited to fill. The space is open not just because memory is fragmented, but because it, like the work itself, has a social context. We are challenged to complete the work by making the commitment of our own memories.

This intimate invitation to the viewer profoundly distinguishes Gonzalez-Torres's work from the Minimalism to which the simplicity and regularity of its form has sometimes suggested comparison. While Minimalism does indeed require the presence of a viewer to articulate itself as art — hence Michael Fried's well-known hostility to the style on the grounds of its "theatricality"[3] — the viewer of Minimalism is accepted only somewhat grudgingly, his or her role limited to that of witness to the art object's insistent claims to autonomy and anti-referentiality. Susan Sontag, in the context of her analysis of a much broader range of art and literature, has expressed the salient qualities of such intransigent work:

Silence is a metaphor for a cleansed, non-interfering vision, appropriate to artworks that are unresponsive before being seen, unviolable

in their essential integrity by human scrutiny. The spectator would approach art as he does a landscape. A landscape doesn't demand from the spectator his "understanding," his imputations of significance, his anxieties and sympathies; it demands, rather, his absence, it asks that he not add anything to *it*.[4]

Austere and reticent as Gonzalez-Torres's work can sometimes appear, its intent, and its effects, are quite different from the aesthetic articulated by Sontag. Gonzalez-Torres's art never *demands*, but if it asks for anything, it is precisely the "anxieties and sympathies" of the viewer. To the extent that it deals with absence — which it does — it is an absence made up of specific losses, an absence filled with feeling. Gonzalez-Torres's decision to work with the formal vocabulary of Minimalism represents a quite conscious desire to weaken the rhetoric of power which has always surrounded that work by recasting its forms as vulnerable and personal. This is work that welcomes the viewer, not as a spectator, but as a collaborator. Rather than asking that you not add anything to the work, Gonzalez-Torres — partly by leaving so much unspoken — creates a situation in which to see the work fully you *must* add something to it: from yourself, from your own history.

This experience of reciprocal participation is heightened by the fact that in many of the pieces, the viewer can literally take part of them away. The work is thus constantly in transition, shrinking as the audience removes sheets of paper or pieces of candy, grow-ing again as the stacks and heaps are replenished. The hard and unyielding surface of Minimalism becomes an open structure that depends upon an experience of generosity and mutual exchange.

Picking up and eating a piece of chocolate from Gonzalez-

Untitled (A Corner of Baci), 1990

Torres's *Untitled (A Corner of Baci)* (1990) establishes the intimacy of this exchange. Can you get closer to a work of art than putting it into your mouth? At the same time, this particular action establishes the centrality of memory in Gonzalez-Torres's work by restaging its most celebrated recrudescence: the scene in which the narrator of Proust's *Swann's Way* tastes a piece of madeleine dipped in tea:

> No sooner had the warm liquid, and the crumbs with it, touched my palate than a shudder ran through my whole body, and I stopped, intent upon the extraordinary changes that were taking place. An exquisite pleasure had invaded my senses, but individual, detached, with no suggestion of its origin. And at once the vicissitudes of life had become indifferent to me, its disasters innocuous, its brevity illusory — this new sensation having had on me the effect which love has of filling me with a precious essence; or rather this essence was not in me, it was myself.[5]

The subject here, as it is in so much of Gonzalez-Torres's work, is the memory of happiness. And this passage also evokes some of the multiple aspects of memory that Gonzalez-Torres puts into play in his work, beginning with its pure *pleasure*. Gonzalez-Torres is not interested in an art that would deny pleasure; he is not suspicious of beauty, elegance, or even sweetness. This last quality is made literal in the many pieces in which he has used chocolate or other candy as his medium. Most adults have become accustomed to thinking of candy as a guilty pleasure, to be indulged sparingly, but Gonzalez-Torres offers us shiny, guilt-free heaps

Untitled (Orpheus, Twice), 1991

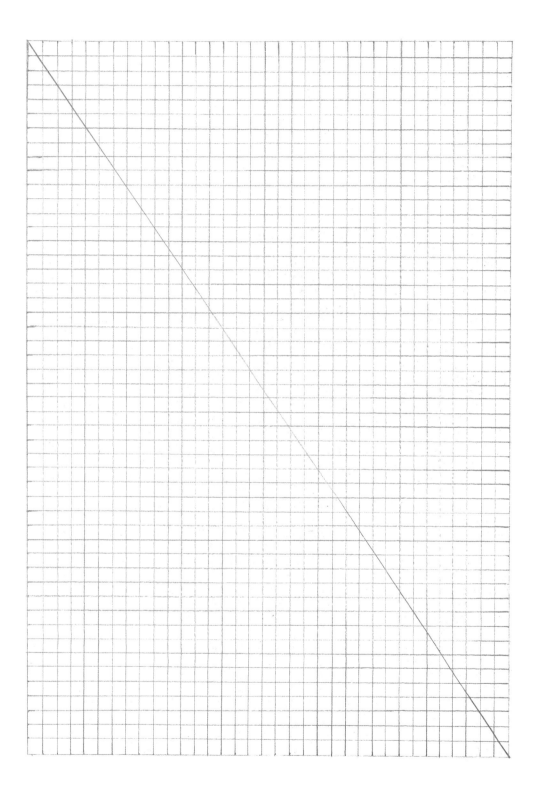

of it, calling up childhood fantasies from before we learned to impose limits to our pleasure.

Pleasure here is closely related to the *physicality* of memory: the "shudder" that runs through the body of Proust's narrator is the physical manifestation of memory in the body. For Gonzalez-Torres, the body is always present in the work, whether it is in the specific weight of candy in *Untitled (Portrait of Ross in L.A.)* (1991), the weight, that is, of his lover's body; or in the absence of one body in the elegiac *Untitled (Orpheus, Twice)* (1991), in which the viewer can see his or her body reflected in a full-length mirror, only to become aware of the empty space reflected in a second mirror hanging alongside the first. In this work, Gonzalez-Torres explicitly calls upon the myth of Orpheus and Eurydice, in which Orpheus, the musician, must journey to the land of the dead to recover his lover, and who is there prohibited from looking back, a prohibition that he feels compelled to break. Even as Gonzalez-Torres implicitly positions himself here as Orpheus, the artist who cannot help but look backward, and who can no longer touch through the mirror's glassy barrier, the title suggests that he is inviting someone else to join him; the second mirror can remain hauntingly empty, or it could perhaps be filled. The piece draws on the myth's story of loss, but also disrupts it by invoking a longing for a couple who might be able to look behind them without each losing the other. It holds out the hope of intimacy.

If *Untitled (Orpheus, Twice)* acknowledges that the look backward carries risks as well as rewards, it also recognizes the power of memory, its ability to reach beyond the disasters of the present, including even the shortness of life itself. Memory offers a path back to the other side of the line between life and death: it is all that remains after the disappearance of the body.

Proust explicitly links the surge of memory to the experience of *love*. For Gonzalez-Torres, too, the backwards look, as it also was for Orpheus, is a loving look. Like an enraptured lover who sits in a reverie, conjuring up image after image of the loved one, small gestures or turns of phrase, Gonzalez-

Torres sifts through his own experiences in search of the moments that separate themselves from the rest. In *Untitled (Still Life)* (1989), those were "Red Canoe 1987 Paris Blue Flowers 1984 Harry the Dog 1983 Blue Lake 1986 Interferon 1989 Ross 1983."

Does that list constitute the 'essence' of a person, of a relationship? It cannot, and Gonzalez-Torres does not make such a claim. There is ultimately no essence, just an endless series of different glimpses of an achronological past that will not remain fixed. For Gonzalez-Torres (as for Proust), memory and identity are both always refracted through other people, through friends, lovers, and strangers as well as through newspaper articles, gossip, and political events. All become part of the intimate web spun between the artist, the viewer, and the world.

The fragility of such a relationship contributes to Gonzalez-Torres's frustration with expectations that as a gay man, or as a Cuban-American, he should be producing work that is more assertive on behalf of those identities. He insists on the right to complexity, the right to a sense of identity that goes beyond rigid categories.

The text that ran along the bottom of Gonzalez-Torres's billboard commemorating the twentieth anniversary of the Stonewall Rebellion *(Untitled, 1989)* is an example of the artist at his most 'public': "People With AIDS Coalition 1985 Police Harassment 1969 Oscar Wilde 1895 Supreme Court 1986 Harvey Milk 1977 March on Washington 1987 Stonewall Rebellion 1969." But does that list qualify as an official history of the long struggle for gay rights? It cannot, of course, any more than the 'personal' dateline in *Untitled (Still Life)* can summarize a great love. But its power as a memorial lies precisely in the spaces between these markers: it makes no attempt to be comprehensive, and it leaves most of

Untitled, 1989

the billboard blank, available space for any viewer to add his or her own memories of twenty years of struggle. And even in this quite specific memorial, Gonzalez-Torres is looking back even further, to include Oscar Wilde alongside Harvey Milk, urging his audience to mix their living memories with a longer history.

Two years later, a second billboard project in New York presented only the image of an empty, unmade bed, unaccompanied by any text. For Gonzalez-Torres both billboards are part of the same continuum. The right to a place of pleasure and comfort, of dreams and reflection, is as important as a declarative claim to recognition. The absence of an explanation can be as powerful as any text, just as the absence of a lover's body can be as meaningful as its presence. By constantly re-inscribing his own memories and experiences in his art, Gonzalez-Torres asserts a changing and multi-faceted identity for himself. This process is highly specific, but profoundly inclusive. Gonzalez-Torres invites us to recognize the complexity of our own lives and our own memories. His work insists that a breeze blowing through the curtains on a summer night, or a snapshot from an almost forgotten childhood, can carry as much weight as any event recorded in official history.

[1] In Robert Nickas, "Felix Gonzalez-Torres: All the Time in the World," *Flash Art* 24, no. 161 (November/December 1991): 87.

[2] Walter Benjamin, "On Some Motifs in Baudelaire," in *Illuminations* (New York: Schocken, 1969), p. 159.

[3] See Fried, "Art and Objecthood," in Gregory Battcock, ed., *Minimal Art: A Critical Anthology* (New York: Dutton, 1968), pp. 116-47. Fried objects to the element of *duration* involved in the perception of Minimalist work, in contrast to the (for Fried) desired situation, in which "at every moment the work itself is wholly manifest." (p. 145) Duration, a consciousness of time passing, is of course far more directly at issue in Gonzalez-Torres's work than in Minimalism. As I argue here, the awareness of past time intersecting with present experience is crucial to his work.

[4] Susan Sontag "The Aesthetics of Silence," in *Styles of Radical Will* (New York: Farrar, Strauss and Giroux, 1969), p. 16.

[5] Marcel Proust, *Swann's Way*, trans. C. K. Scott Moncrieff (New York: Modern Library, 1928), p. 62.

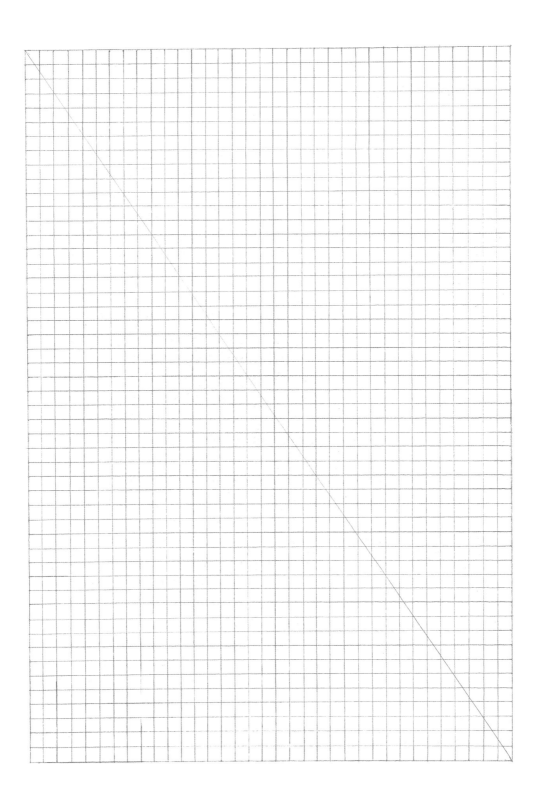

Untitled (Ravenswood)

Ann Goldstein

For about five months in 1990, Felix Gonzalez-Torres and Ross Laycock lived in the same apartment building in which I live, the Ravenswood, while Felix was a visiting artist teaching at Cal Arts. Neither I nor my husband Christopher was aware that they were in the building until some time into their stay, when Christopher recognized Felix while riding together in the elevator (Felix says that he initially thought Christopher was from the I.R.S.). Our mutual residence led not only to friendship but to a unique insight into Felix's union of life and work, particularly through the special role that the building played, and continues to play, in both.

The Ravenswood is one of a small but distinctive group of late 1920s Art Deco buildings on Rossmore Avenue, just south of Hollywood. A few blocks from Paramount Studios, with a view of the Hollywood sign up in the hills directly to the north, the Ravenswood shares with its neighbors a rich past as home to many people who worked in the entertainment industry, both in front of the camera and behind the scenes. It is particularly known for its roster of former celebrity inhabitants, most notably Mae West, who lived there from 1932 until her death in 1980.

Now quaintly dilapidated, the Ravenswood is a seven-story building with nearly one hundred apartments. Like its neighbor the El Royale, the building has a distinctive rooftop sign. The Ravenswood sign is now missing its initial 'R' which fell off some years ago and has not been reattached. The facade features a subtle zigzag 'Assyrian' style design, while the entrance lobby, best characterized as eclectic, appears to have been last redecorated in the 1960s in a pseudo-Mediterranean style. Its features include an enormous crystal chandelier, generic paintings of Venice, a vast rust-colored carpet that almost entirely covers the original terrazzo floor, two notoriously erratic old elevators, and an adjoining sitting room with deep orange walls (now with some fierce post-earthquake cracks). Originally, the Ravenswood was a full-service apartment-hotel, complete with elevator operators, parking attendants, an in-house laundry service, etc. Today, the only remnant of its full-service days is a twenty-four-hour telephone switchboard and desk clerk. To the side of the building, situated on a plot of land at least as big as the building itself, is an unkempt pool and garden area with a glass cabana, a smattering of tropical plants, and tables topped with large yellow metal umbrellas.

It was by chance that Felix found the Ravenswood. Driving around the city looking for a place to live, he came upon Rossmore Avenue and immediately was drawn to the name of the street: ROSSmore. Impulsively, he decided that the street was where he and Ross would live, and quickly rented

apartment number 407 at the Ravenswood, which looks down upon the adjacent pool area through the top of a cluster of tall bamboo trees and, in the distance, at the illuminated green neon sign atop the more elegant El Royale.

For me, the Ravenswood

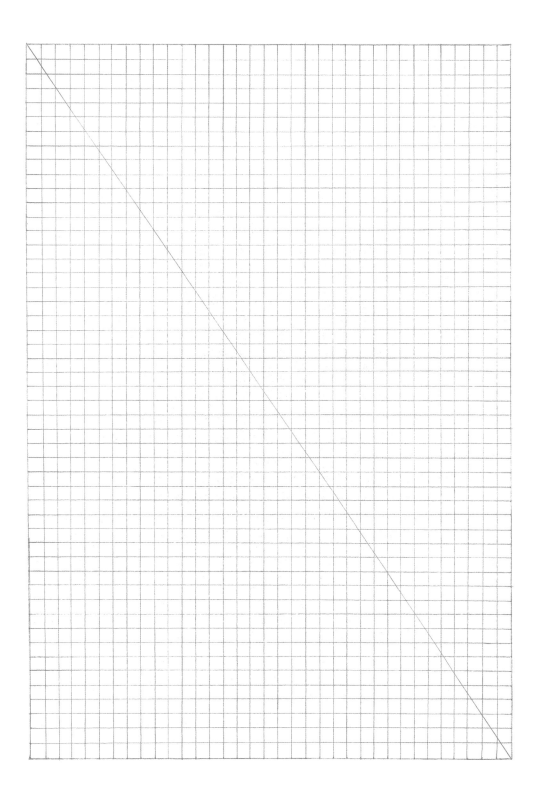

was my home and the bedrock of my private life; I had been drawn to it through its distinctive architecture and New York-style scale, its sweeping city views, and its strong connection to an earlier era, particularly the aura of late 1920s Los Angeles and the early days of Hollywood. For Felix and Ross, it became much more than a characterful, temporary place to live. It was at once a joyous and painful interlude in their eight-year relationship — and a culmination. The Ravenswood marked the first and only time and place that Felix (who lives in New York) and Ross (who lived in Toronto) actually lived together. Ross, who was already quite ill from the effects of AIDS, died in Toronto in January 1991.

That short period of time served not only as the foundation of our friendship, but also helped to crystallize my understanding of Felix's work — although at the time we rarely spoke about it. I write about it here not to include myself in his history, and not just because of the profound, indelible presence the building maintains in Felix's life and work, but because of the nature of his work in general, which subtly yet emphatically intensifies one's own self-awareness, subjectivity, and sense of personal history. In effect, his work insists upon the inclusion of the complexities of those areas most preciously protected or deeply repressed — it sets up a conflation of 'public' and 'private,' and the personal with the professional. As David Deitcher has described it, his work "ensures the evocation of a complex 'everyday,' one that weaves together public and private, political and personal, present and past, conscious and unconscious, intellectual and emotional, familiar and unknown, systematic and unpredictable."[1]

Felix's work possesses the ability to invest the abstract and the mundane with emotional content. He can extract the tangible from the intangible, and vice versa. His materials — stacks of printed sheets of paper, strings of light, wrapped candies, as well as words and dates describing statistical, historical, or personal events — are vehicles for meaning, directed, but never overarticulated, by the artist. His work taps into the underlying power of the cliché without succumbing to sentimentality, distilling from it its orig-

inal impulse in shared desires and common experience.

While Felix has not referred explicitly to the Ravenswood in his work, there have been two pieces, both made after Ross's death for exhibitions in Brussels and Los Angeles, that have invoked the name of Rossmore Avenue. The first work, *Untitled (Rossmore)*, made in 1991, was a fourteen-foot line — like a street — of bright green wrapped candies. The other work, a single string of lights also titled *Untitled (Rossmore)* was made a year later in fall 1992. Recalling the joyful moment when Felix and Ross made a personal connection to Rossmore Avenue, Felix, after Ross's death, used the name of the street in these works to remember Ross, and the memory of optimism.

In an interview with Robert Nickas, Felix stated: "Meaning is created once something can be related to personal experience."[2] While his works stem from his own specific experiences, they transcend autobiography and manneristic expression through the use of common points of reference. As Jan Avgikos has written:

> Aided by synthesizing allegorical structures that interweave public events and private moments, he works against the expressionist model, based on an expressive self and an emphatic viewer who receives preconstituted meanings, by proposing a collective social and psychic space in which the beholder actively participates in the construction of meaning. Though his work is informed by autobiographical elements specific to his homosexual identity, its intent is to extend subjectivity to all participants.[3]

Although I have written about a personal connection to his life, it is not necessary to know Felix personally to understand or participate in the work. The process by which the viewer becomes a participant is a result of an open and dynamic form that is deeply generous. Whether it is a sheet of paper that can be taken from a stack, a piece of candy that can be enjoyed, or the recognition of a common experience, the work offers the viewer the opportunity

to draw one's own intimate experiences into the construction of its meaning.

Felix buried some of Ross's ashes in the grounds of the Ravenswood, at the base of the bamboo trees that stretched up to their living room windows. Now, four years after he and Ross lived here, the Ravenswood remains a constant reference point in Felix's life. The intensity of my own memories and feelings of attachment to that time has been further heightened not only by this shared experience but also by its complex incorporation into Felix's continuing body of work. It is as if Felix has created another work, *Untitled (Ravenswood)*. Through it, I link his experience to mine, and reflect upon the life that Christopher and I have shared in this building, and how Felix and Ross are part of our past, and our future.

[1] David Deitcher, "The Everyday Art of Felix Gonzalez-Torres," in *Felix Gonzalez-Torres* (Stockholm: Magasin 3 Stockholm Konsthall, 1992), n.p. When Deitcher was invited to teach at Cal Arts, he also chose to live in the Ravenswood, and he, too, was offered, and chose to live in, apartment 407.

[2] In Robert Nickas, "Felix Gonzalez-Torres: All the Time in the World," *Flash Art* 24, no. 161 (November/December 1991): 87.

[3] Jan Avgikos, "This Is My Body: Felix Gonzalez-Torres," *Artforum* 29, no. 6 (February 1991): 82.

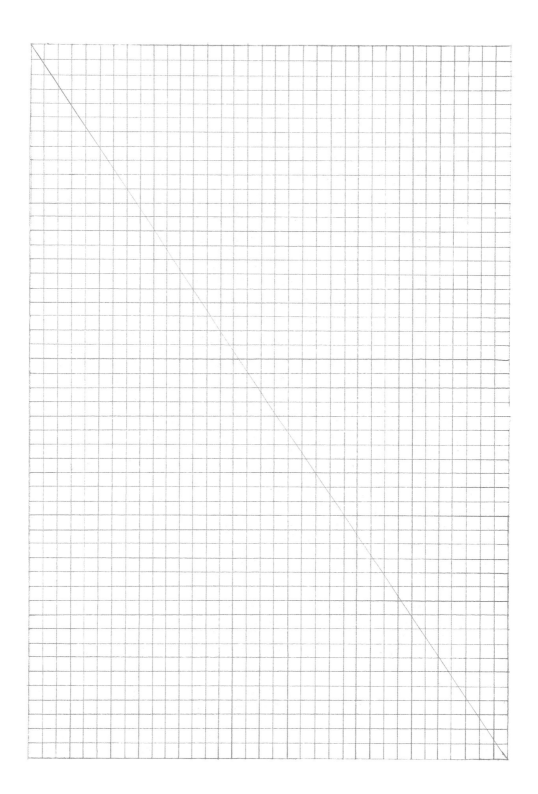

subversive beauty:
new modes of contestation

bell hooks

When Keats wrote the lines, "A thing of beauty is
a joy forever, its loveliness increases, it will never
pass into nothingness," he attributed to beauty the
subversive function of sustaining life in the face of deprivation, unrelenting
pain and suffering.

In the work of Felix Gonzalez-Torres beauty is also a life force, affirm-
ing the presence of intense intimacy, closeness, our capacity to know love,
face death, and live with ongoing yet reconciled grief. Unlike Keats,
Gonzalez-Torres insists in his work that beauty is not best expressed or
contained in the enduring art object; rather in the moment of experience,
of human interaction, the passion of remembrance that serves as a catalyst
urging on the will to create. The art object is merely a mirror, giving a glimpse
that is also a shadow of what was once real, present, concrete. It is this
invitation to enter a world of shadows that his work extends.

Shadows become the location of our destiny, outlining the shape of past,
present, and future possibility. Whether expressed in the enfolding black-
ness that serves as a background for signs of decontextualized history —
seemingly random but connected events; in the photographic image of a

once inhabited but now vacant bed; or in a pattern of birds' flight among gray clouds, in Gonzalez-Torres's work there is always the insistence that elegance and ecstasy are to be found in daily life, in our habits of being, in the ways we regard one another and the world around us. It is sacrilege to reserve this beauty solely for art.

Taking the familiar, the everyday, the mundane, and removing it from the realm of domesticity, Gonzalez-Torres's work disrupts boundaries, challenges us to see and acknowledge in public space all that we have been encouraged to reveal only in private. Bringing us face to face with our emotional vulnerability, our lack of control over the body, our intense longing for nurturance (the bits of candy we are allowed to take and suck remind us of our engagement with the world of the senses), this art restores the primacy of our bond with flesh. It is about exposure and revelation. It indicts the audience. We are witnesses unable to escape the truth of what we have seen.

Jet black backgrounds provide the perfect blank screens for the projection of our individual understanding of realities named yet undefined by the printed text. When we see photographs of a billboard that reads: "People With AIDS Coalition 1985 Police Harassment 1969 Oscar Wilde 1895 Supreme Court 1986 Harvey Milk 1977 March on Washington 1987 Stonewall Rebellion 1969" we are not innocent onlookers asked to escape into a world of the artistic imaginary. Here in this moment of testimony art returns the gaze of the onlooker demanding an interrogation of our individual subjectivity — our locations. Who were we, where were we, how did we experience these events.

All the pieces by Gonzalez-Torres that make use of 'date lines' resist consumption as mere artifact by the inherent demand that audiences participate, that

Untitled (Strange Bird), 1993

we make 'sense' of the world mirrored here. As counter-hegemonic art, it requires that we identify not with the artist as iconic figure or with the beautiful art object, but rather that we identify ourselves as subjects in history through our interaction with the work. This is not art that subliminally subjugates, coercively enthralls or enraptures. It welcomes our presence — our participation.

The presence is made more manifest by the spaces left vacant in the work itself that leave room for us. This was most evident in the photograph of the unmade bed, rumpled, marked by the imprint of missing bodies, that loomed large on billboards throughout New York City (*Untitled*, 1991). This image taunted us with remembered connection. Where the body of love could be, where the intimacy of lying close could be seen, there was only absence. Each individual looking into that vacant space must come to terms with what is not there. Once again Gonzalez-Torres gives us art that is not meant to usurp, stand in for, or replace experience.

This art returns us to experience, to memory. What we feel and know with our senses determines what this absence means. There are many ways to "read" this image. Those who come to it with autobiographical details from Felix Gonzalez-Torres's life can see projected here the loss of his lover, the impact of AIDS, the power and pleasure of love and loss, the anguish of grief. Yet for the masses of viewers who saw this work without such intimate details, this black-and-white image of an empty bed is a shadowy place to be entered not through empathy with the artist, but by way of one's own relationship to loss, to absence, to leave-taking, to remembered grief.

Inviting audiences to remember moments of closeness and separation, this image is a passage linking the particular losses we experience with a culture

Untitled, 1991

of collective grief. All our diverse losses, unnamed sorrows, undocumented deaths can find expression as we gaze upon this bed where living bodies might lie together, leave their mark. We confront an absence that is also a trace leading back so that we can bear witness to the intimacy that was present. Although the bodies are gone, memories sustain the experience, allow the feelings these bodies generated — the warmth and passion — to be revealed, recalled, recorded.

In the stillness of this image can be heard the sounds of lives content, fulfilled. It is that aura of satisfaction that this image embraces, resurrects, bringing to life a vision of hope and possibility. The absence in this image is not meaningless death. What we see is a pedagogy of mourning that teaches us to understand that life well-lived shapes the nature of our journey, our passage, from the moment we are born to the day we die.

There are intimations of immortality in this work and the work that follows, a sense of eternity that extends from this image into the more recent images of dark clouds where solitary birds fly. Gonzalez-Torres gives us a passport with no place for irrelevant details, where we were born, in what country, dates or numbers. A passport of dark clouds, of birds in flight, moves us to a space beyond history, a space of mystery where there is no record, no documentation, nothing to recall. What is captured here is a moment of utter oneness where the experience of union, of perfect love, transcends the realm of the senses. No boundaries exist. There are no limits.

Untitled (Passport II), 1993

In the work of Felix Gonzalez-Torres this call for reunion is a political moment, an act of resistance. Once we embrace his vision of the collapse of public and private, the convergence of the individual and the collective, we open ourselves to the possibility of communion and community. The beauty of that union

is celebrated in Gonzalez-Torres's work. Yet as the signs, symbols, 'date lines' tell us, that union will not come without struggle and sacrifice, without active resistance against those forces of domination that seek to shut down our agency, our will to be self-actualized. Gonzalez-Torres's art declares that to be political is to be alive — that beauty resides in moments of revolution and transformation even as his work articulates "new modes of contestation."[1] In grappling with subversive beauty, with aesthetics of loss, Gonzalez-Torres insists that our lives be that space where beauty is made manifest, where the power of human connection and interaction creates that loveliness that "will never pass into nothingness."

[1] Robert Nickas, "Felix Gonzalez-Torres: All the Time in the World," *Flash Art* 24, no. 161 (November/December 1991): 87.

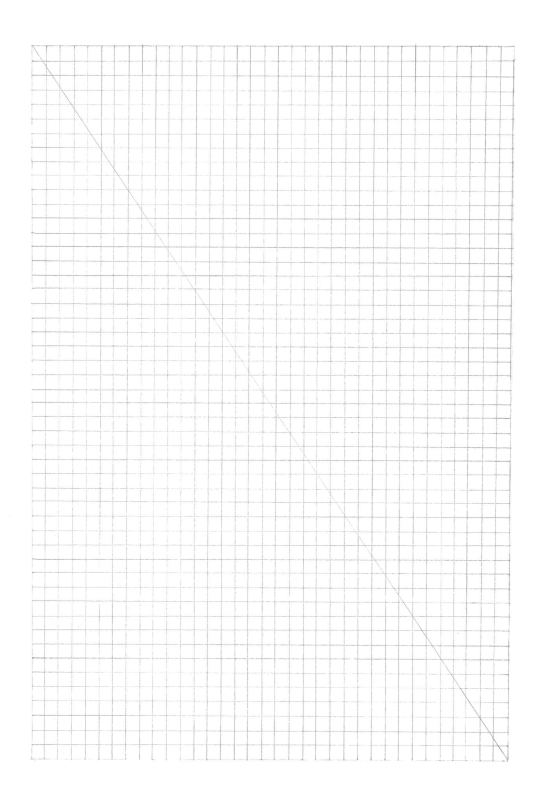

Exemplar

Joseph Kosuth

*The eye of the intellect sees in all objects what it brought
with it the means of seeing.–Thomas Carlyle*

Whatever one would want to say about that project
called Conceptual art, begun nearly thirty years ago, it is clear now that what
we wanted was based on a contradiction, even if a sublime one. We wanted
the *act* of art to have integrity (I discussed it in terms of 'tautology' at the time)
and we wanted it untethered to a prescriptive formal self-conception. Paul
Engelman, a close friend of Ludwig Wittgenstein and the collaborator with
him on the house for Wittgenstein's sister, has commented about tautologies
that they are not "a meaningful proposition (i.e. one with a content): yet it
can be an indispensable intellectual device, an instrument that can help us —
if used correctly in grasping reality, that is in grasping facts — to arrive at
insights difficult or impossible to attain by other means."[1] What such ques-
tioning directed us toward, of course, was not the construction of a theory
of art with a static depiction (a map of an internal world which *illustrates*) but,
rather, one that presumed the artist as an active agent concerned with mean-
ing; that is, the work of art as a *test*. It is this concept of art as a test, rather

than an illustration, which remains. What, then, is the contradiction?

It is as follows. How can art remain a 'test' and still maintain an *identity* as art, that is, continue a relationship with the history of the activity without which it is severed from the community of 'believers' that gives it human meaning? It is this difficulty of the project (referred to now as Conceptual art) that constituted both its 'failure' — about which Terry Atkinson has written so well[2] — as well as its continuing relevance to ongoing art production. It would be difficult to deny that out of the 'failure' of Conceptual art emerged a redefined practice of art. Whatever hermeneutic we employ in our approach to the tests of art, the early ones as well as the recent ones, that alteration in terms of how we make meaning of those 'tests' is itself the description of a different practice of art than that which preceded it. That is not to say that the project did not proceed without paradox. Can one initiate a practice (of anything) without implying, particularly if it sticks, a teleology? Even at the end of modernism a continuum is suggested. This is one of the ways in which its success constituted its failure. What it had to say, even as a 'failure,' still continued to be art. The paradox, of course, is that the ongoing cultural life of this art consisted of two parts which both constituted its origins and remained — even to this day — antagonistic toward each other. The 'success' of this project (it was, in fact, believed as art) was obliged to transform it in equal proportion to its 'success' within precisely those terms in which it had disassociated itself from the practice of art as previously constituted. Within this contradiction one is able to see, not unlike a silhouette, the defining characteristic of the project itself: its 'positive' program remains manifest there within its 'failure,' as a usable potential. One test simply awaits the next test, since a test cannot attempt to be a masterpiece that depicts the totality of the world; indeed, it is only over the course of time that the process of a practice can make the claim of describing more than the specific integrity of its agenda. It is such work, like any work, located within a community, that gives it meaning as it limits that meaning.

What is the character of such 'tests?' As Wittgenstein put it: "In math-

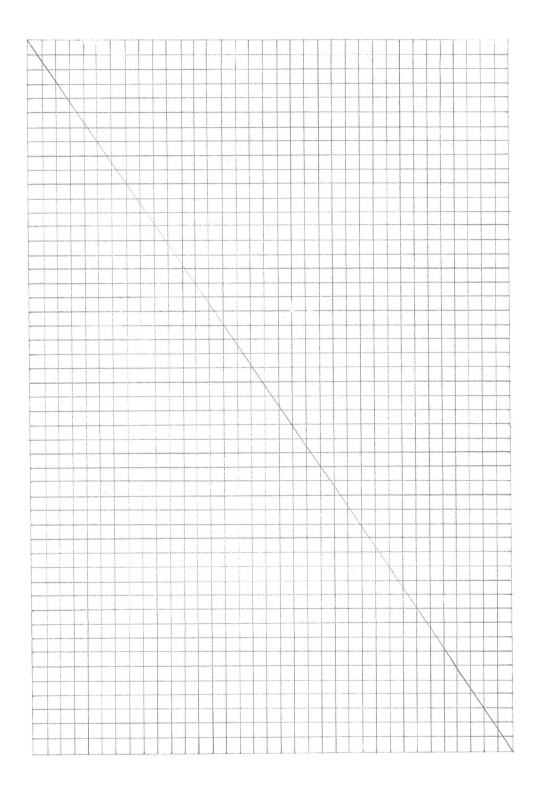

ematics and logic, process and result are equivalent." The same, I would maintain, can be said of art. I have written elsewhere that the work of art is essentially a *play* within the meaning system of art. As that 'play' receives its meaning from the system, that system is — potentially — altered by the difference of that particular play. Since really *anything* can be nominated as the element in such a play (and appear, then, as the 'material' of the work) the actual location of the work must be seen as elsewhere, as the point or gap where the production of meaning takes place. In art the how and why collapse into each other as the same sphere of production: the realm of meaning.

As for the project of Conceptual art, we know that what is 'different' doesn't stay different for long if it succeeds, which is perhaps another description of the terms of its 'failure.' Thus the relative effectiveness of this practice of art was dependent on those practices of individuals capable of maintaining a sufficiently transformatory process within which 'difference' could be maintained. Unfortunately practices begun in the past are subject to an over-determined view of art history whose presumptions are exclusive to the practice of art outlined here. The traditional scope of art historicizing — that is, the definition of a style attributed to specific individuals — is most comfortable limiting itself to perceived early moments which are then dated and finalized. While such 'credits' make sense emotionally for the individuals concerned, we've seen where it stops the conversation just where it should begin. In actual fact, the continued 'tests' of the original practitioners should be considered on their own merit along with the 'tests' of other generations, insofar as all are relevant to and comprise their own part of the *present* social moment.

Finally, that which proves to be useful now from this project is one and the same as that which immunized this particular practice from the ravages of a concept of progress. It is the accessibility of its theoretically open 'methodology' (if only loosely meant as an approach) that has remained viable to a culturally nomadic (even within late capitalism) set of practitioners. Enter here Felix Gonzalez-Torres, stage left.

That monographic tradition referred to above will, undoubtedly, have somewhat other things to do with the work of Gonzalez-Torres. This text has another purpose. I am writing as an older artist who was there at the beginning of a particular process, yet one who is sharing a present context with younger artists. There can be indices on a variety of levels, some superficial and some not, which connect such diverse practices within a cluster of shared concerns, but occasionally the work of a particular individual is exemplary, and such is the case with Felix Gonzalez-Torres.

If one looks through the writing on his work over these past five years, the references most often cited have been to Minimal and Conceptual art. Unfortunately, because of the level of understanding of much of the writing on these topics, the use of these terms tends to block the light rather than enlighten. My interest here is to initiate an attempt to describe the intellectual tradition within which Felix Gonzalez-Torres works as an artist, and his importance now to that tradition as a difference.

Minimalism, still functioning (even if in protest) as an art conceived of in terms of form, offered to my generation the possibility of a tabula rasa, cleansed of the prior meanings collected by modernism. Formed in negation as a signifying activity (before it was made into sculpture by the market), Minimalism had much to say about what was no longer believable in art. To this end, Minimal art was a stoppage and clearing out; it cleaned the wall of other marks to make way there for the handwriting that was to follow. All that was a long time ago. The recycling now of the Minimalist glossary by Gonzalez-Torres constitutes its re-erasure of prior meaning in yet another way. If anyone doubts that artists work with meaning and not form, consider the literature on Minimalism at the time, with its criticism of this work as being simply a replication of Constructivism. Constructivism, Minimalism, Gonzalez-Torres: it goes a long way to show the role of context in the perception and meaning of a work of art. The conceptual 'virus' (as Gonzalez-Torres has described his role) that inhibits the corporal presence of his Minimal forms is, of course, that of supplanted meaning. The corpus of his

work is beyond the form his 'host' takes. The basis of a conceptual practice is not what you see but what you understand. It is this process of coming into understanding that links the viewer/reader with the work and concretizes that experience as part of the same event that formed the work, as meaning. The viewer/reader then becomes part of the meaning-making process, rather than being put in the role of passive consumer.

The image-referent of Minimalism succeeds in denying its 'objecthood' and here is where Gonzalez-Torres's work leaves behind Minimalism: he contains it as parody. The meaning made is Felix's. This is ensured by maintaining an instability in the work as object, goods, or material. The illusion of an image or object is the illusion of static representation, since what is seen is a frozen moment of its fragmentation and dissemination (they're often there for the taking). The dynamic of that particular movement is as much the material condition of the work as is whatever formal properties the work shares with what preceded it. Where it comes from (ordered from commercial sources), how long it stays (it sits there, and temporarily behaves as an artwork is expected to), and where it goes (questions arise about the cultural meaning of a fragment, unsigned, which could — perhaps — consign it back to its commercial origins . . . yet only almost, since it retains a trace of Felix's subjectivity and political life).

What is the cultural life that Gonzalez-Torres has added to his 'host?' We can see, in another context, that expression institutionalized into Expressionism created a paradox of impersonal generalized marks intended to celebrate the personal. The signifying role of auratic relicry which we inherited from Christian ritual found another cultural life in the market, but ritual without religion is simply a stage for authority, albeit in the guise of 'quality.' Of course art is a form of expression, what else could it be? Such a truth is truistic, however, and we can thank Expressionism for how 'expressive' all the work now looks that was once called anything but. We know now what Expressionism was expressing: Expressionism. What can really be said about expression itself, as a generalization, once it is in the work?

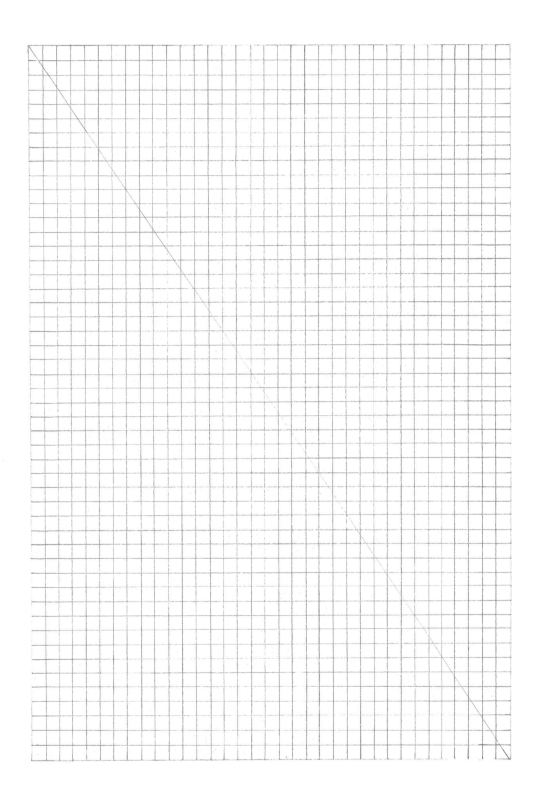

If it is not a generalization, but specific, then it has a kind of functional 'content' which is part of the work's play, with no role as 'expression' per se. The institutionalized expression celebrated in earlier forms of painting seems to pale in relation to this artist's use of personal experience to ground works made with 'impersonal' materials. But it is even wrong to put it that way. This work, like all of the best work in this century, is about meaning, and the value of the work doesn't reside in the props employed to construct that meaning but in the authenticity of that manifestation which the integrity of one individual can assert. Perhaps the most eloquent demonstration of a difference between Gonzalez-Torres and Minimalism might be to consider — for a moment — the same wrong move twice. In the first wrong move we look to the fluorescent light of Dan Flavin — to the object, with a bulb, bought in a hardware store — and try to find the meaning of this work in its materials. We then look to one of Gonzalez-Torres's stacks of paper, also trying to find meaning there, in that stack. We know that both have something to say about an activity called art. Is not the important difference between these artists how they arrive at the condition of art: what we learn from that passage of impersonal materials into products of subjective responsibility? What is the meaning that stands in the gap between a pile of Gonzalez-Torres candies and a stack of paper that shapes what we see and organizes our thoughts? What, now, does a fluorescent light by Flavin tell us?

One asks these questions to get beyond the object. In a world of objects, we need to know what separates the 'objects of art' from the rest. What the work of Felix Gonzalez-Torres suggests to us is that one can have much to say within the context of art without sacrificing the personal connection to one's work which keeps it within a real social space, and which, as well, gives work a political grounding. Politics, in the case of Gonzalez-Torres, is not an abstract message that reduces work to a passive purveyor of 'content' — as illustration — but, on the contrary, is a socially-based activity which makes the viewer/reader part of the cultural act of completing the work.

[1] Paul Engelmann, *Letters from Wittgenstein, With a Memoir* (Oxford: Basil Blackwell, 1967), p. 105.

[2] Increasingly, after 1970, the intrusion of "the philosophically interrogative subject into the construction of artistic identity/subjectivity" — as Atkinson has put it — began to wind down as a concern. From the point of view of Atkinson and myself (in marked contrast to what now goes under the name Art & Language) the 'return to painting' of the eighties was in the main a failure of historical nerve in art practice, a fatigue in the face of the complex legacy of Conceptualism which buckled under the market's pressure for 'quality defined' traditional forms of art. For more on Terry Atkinson's point of view, see his "The Indexing," in *The World War I Works and the Ruins of Conceptualism* (Belfast: Circa; Dublin: Irish Museum of Modern Art; Manchester: Cornerhouse, 1992); *The Bridging Works 1974* (London: Mute Publications, 1994); "The Rites of Passage", in *Symptoms of Interference, Conditions of Possibilities: Ad Reinhardt, Joseph Kosuth, and Felix Gonzalez-Torres* (London: Camden Art Centre, 1994); and "Curated By The Cat," presented as a lecture at the Camden Art Centre, January 8, 1994, and as a forthcoming publication.

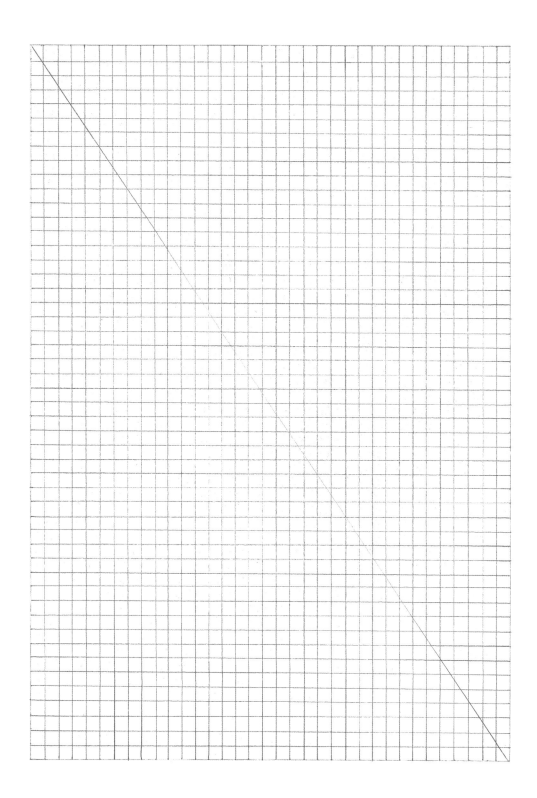

The Spirit of the Gift

Charles Merewether

What is given in the work of Felix Gonzalez-Torres? I remember standing in a museum in front of a stack of sheets each covered with the same photograph of the sea. At some point, a woman took a sheet from the stack, carefully rolled it up, placed it under her arm and moved on. People looked slightly perplexed, and then another went to the stack and did the same. Finally I too went over. Yes, an image of the sea, I said to myself, how beautiful, the wide open sea, as I remembered my days spent overlooking the Pacific Ocean from my window. I looked up, someone smiled. I returned the smile and then left with the gift beneath my arm.

As I walked away, I thought of how strange it was that this work would soon disappear, except for a label marking its absence. But it was the image of the sea that had more deeply impressed itself upon me. When I returned home, I discovered there was nothing but the sea. But in its sheer plenitude, its openness, I found myself as if consumed, already in another place, in another time. The work of Gonzalez-Torres brings to us this possibility, this possibility to participate in the meaning of the work. Such is its generosity.

And yet in saying this, let me first take stock of what we have in hand,

before framing it too quickly. For while what Gonzalez-Torres had made for the exhibition, and for those who took one or more, represented nothing but a simulacrum of the work of art, the sheets as given obtained a special value, a value which we as audience invest in symbolically. As such they each constituted a form of gift.[1]

The Gift-Exchange

In 1925 Marcel Mauss published his essay "The Gift" on the pre-capitalist institution of gift-exchange.[2] He outlined how it informed the aesthetic, moral, economic, religious, and material dimensions of communal life in various cultures. This structure of gift exchange then provided the basis for the development of the later economic organization of capitalism. Regulated by laws of contract, interest, debt, lease, credit, etc., social exchange became governed by concepts of private property and ownership, the private sector and public sphere. This created an order governed by an economy of calculated expenditure and utilitarian exchange.

In exploring the practice of gift exchange, Mauss discovered an extraordinary instance of it in the custom of 'potlatch' amongst the Kwakiutl Indians of the American Northwest. Not only did the production and consumption of goods constitute the foundation of social exchange, but the giving of gifts and the obligation to return the gift engendered rivalries and struggles for power. The obligation of worthy return is imperative, an expenditure without reserve. But power is not gained by the acquisition of goods, but the power to lose. Rather than a principle of conservation, it is one of expenditure, and in the demand to not only meet but exceed the gift-giving lies the threat of destruction and war.

However, while gift-giving inaugurates a certain obligation, it is also incalculable, and always in excess of exchange as governed by laws of accounting (the balanced books) and utility. Yet if the giving of the gift is done without

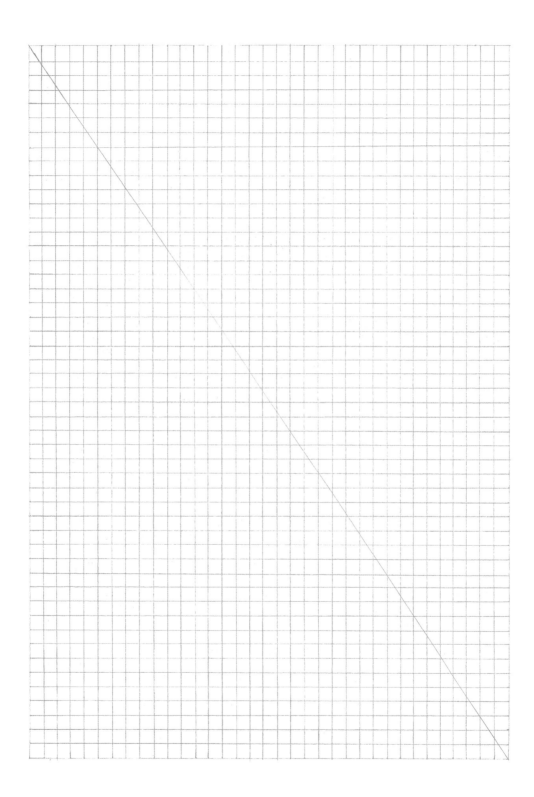

reserve and there is no profit to be had, is there not a different economy at work? The gift must appear as anything but a gift; it must be forgotten. As Derrida notes: "For there to be forgetting . . . there must be a gift. The gift would also be the condition of forgetting."[3] Detour and deference on the one hand, and separation and abandonment on the other. This paradox characterizes Derrida's concept of 'difference,' in which Freud's distinction between the pleasure principle (the ego's instinct of self-preservation) and the death instinct (expenditure, irreducible usage of energy) govern social life.[4] Does not then expenditure, whether it be in the political economy of capitalism or in the libidinal economy of the unconscious, always already entail a condition of sacrifice and loss? There is a sense of giving over oneself. A gesture of generosity that experiences loss without reserve. The art of Gonzalez-Torres addresses the paradox of the gift in contemporary society, a life in which eros and thanatos are inseparable, in which one person's gift is another's poison, yet life without giving oneself is no life at all.

In the Presence of Others

To give back meaning to people is a way of going public, of turning memory, autobiographical memory, into the memory of others, a sharing of experiences, one's life. Such are the large and small events of daily and collective life, of the private and public world of commemoration and ritual, binding together persons, collectivities, communities, nations.

A piecing together of memory, as if the different fragments shared might make whole again something lost. Over a period of some four years (1988-1991) Felix Gonzalez-Torres made a series of jigsaw puzzles. They were based on both personal and found photographs. Family portraits, land-scapes, friends, lovers, love letters. While acknowledging the impossible restitution of the past except through its traces, the jigsaw puzzle offers the possibility of making sense of fragments of memory, of that which is forever

absent. As a work of art, this double movement shares the remains of private and intimate experiences, without the foreclosure of language. What is important is the recognition of an/other, the desire to correspond, of giving oneself to the subject of address. The time spent on the subject of one's desire, the erotics of letter writing, the folding of sheets, the slipping between the envelope, arriving.

During 1991 Gonzalez-Torres produced a series of billboards depicting an empty double bed with the imprint of its occupants left on the sheets and pillows. In the 1986 case of Bowers versus Hardwick, the Supreme Court ruled that the right to privacy did not cover certain sexual acts, especially homosexual acts. The bed is once again a legislated and contested space.[5] Between the folds Gonzalez-Torres uncovers an agency of repression, whereby taboos are not only constructed but also broken by the State. The State exercises a moral authority over the individual by determining what should be a private matter and what should be public. As Gonzalez-Torres has suggested "our intimate desires, fantasies, dreams are ruled and intercepted by the public sphere."[6] In these terms, he intimates that the transgression may be committed by the State as well as by the individual.

Perhaps there is another staging here, the testimonial rather than the confessional or psychoanalytic. The making known in public what has remained unacknowledged experience, such as homosexual love — that which could not be spoken of — has been the object of suppression or prohibition and therefore hidden from view, privatized. Coming out. The slipping in and out of the public sphere. What are and who draws such lines?

By going public, appropriating spaces reserved for publicity, Gonzalez-Torres also challenges the privatization of property and the market place. The image opens up the borders that exist between the private and public sphere. Placed into the public realm, his work forces us to acknowledge not only the separation between the public and private, but that such distinctions serve to valorize certain interests and delegitimate others. Gonzalez-Torres leaves the unmade bed open for any viewer to invest it with meaning. And, as in

other work, this openness which allows for both a social critique and a personal interpretation makes for a recognition that the issue affects all of us in one way or another.

Gonzalez-Torres offers us a space structured by an experience of pain and of pleasure, loss or hope, memory and forgetting. Looking at the image of an empty bed disrupts the coarse textures of the urban street, breaks the anonymity of the crowd and draws us into the folds of intimacy, making us dream of tactile places and the sensorium of the body. Like the fragments of letters, the empty bed recalls the absent lover, the site of pleasure, the shared experience, the intimacy of companionship, of being with another. This openness towards the other, a recognition of difference in the production of both meaning and value, carries within it the idea of forming a community.

In 1989 the artist, with the support of the Public Art Fund, rented a billboard on the corner of Christopher Street and Seventh Avenue South in New York. It consisted of a pure black surface with a two-line inscription running along the bottom edge: "People with Aids Coalition 1985 Police Harassment 1969 Oscar Wilde 1895 Supreme Court 1986 Harvey Milk 1977 March on Washington 1987 Stonewall Rebellion 1969." The text punctures the resistant opacity of the black. It disrupts the rhetoric of neutrality quintessentially evinced by the late modernism of Minimalism. By bringing Minimalism into close association with advertising, subjectivity's site of deferral is exposed. Rather than the promise of transformation through consumption, the space for our imaginary projection, the black background forms a space for mourning the loss of a loved one to sickness, to AIDS. And the text also defies this site of erasure and repression. The narrative of the script unfolds the struggle of the gay movement that has not ceased.[7]

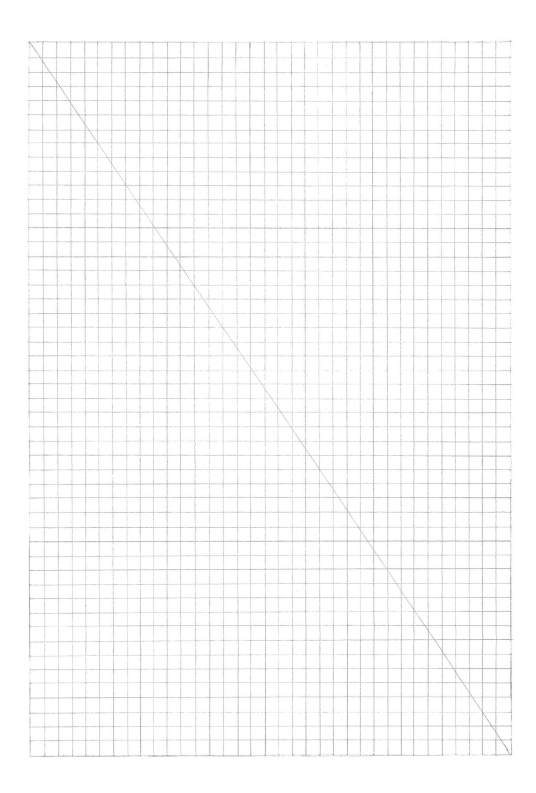

Minimal Gestures

Reproducibility and repetition are not only fundamental tenets of modern capitalism and mass culture, but index the concept of seriality in Minimalism. Gonzalez-Torres repeats these gestures, but reinscribes their signification, in order to mark both the possibility of loss and the potential for renewal. As with the stacks, where each sheet taken recalls the disappearance of another, and equally the constitution of a community, so the billboard expresses the irreducible evidence of loss, but as much the capacity for hope and rejuvenation.

In a project for a new museum on the outskirts of Caracas, Gonzalez-Torres has proposed to use the same image both inside the museum and outside in the neighboring streets. Situated in a park opposite a high-security prison and in a neighborhood of local and immigrant workers, the artist will install a string of lights and a series of large billboards of an open hand.[8]

Such minimal gestures appear to replicate the industrial processes of capitalism in which the body is subject to fragmentation — the mind, the eye, the hand — and reification.[9] Workers become defined by their manual skills and their wage labor is transformed into an exchange value through consumption. In the 1960s, Minimalism reproduced the effect of this division through stressing the 'objecthood' of the work. Viewed as impenetrable, neutral, without relation to its viewer, the work conformed to the alienation and anxiety of contemporary social life.

An attempt to overcome the negative estrangement of Minimalism and the recuperation of Pop art by the very forces it sought to ironize through mimicry (i.e., the commodity and mass media), came initially from conceptual artists of the 1970s and 1980s. Dis-

Untitled (For Jeff), 1992

solving the object, they developed a critique of language as a mode of production. Focusing on the agencies of publicity, information, and bureaucracy, they viewed their work as a strategic institutional critique of the culture industry and its systems of communication and representation. And yet in mounting such a critique they left themselves radically purified, but without a subject or a form by which to critically disengage from the alienation produced by the cultural logic of capitalism. Their construction of freedom existed by virtue of their object of critique and therefore as a form of negative dialectics. While Gonzalez-Torres's work is clearly indebted to Conceptual art, he has striven to go beyond this quality of reductive self-referentiality.

In offering a hand, Gonzalez-Torres seeks to intervene in the public arena by reinstating its subject of address. And, in the context of its location and audience, the image assumes a different specificity. Rather than an object of investment (consumption), he brings back the subject of production (the worker) through the system of publicity and circulation (the advertisement, billboard), as the viewing 'body.' The string of lights and the image of the hand become signs of festive reunion and an artwork that inaugurates the opening of a museum, a symbol of cultural exchange and community.

The image of a hand embodies the slippage that occurs between production and reproduction as an economy of representation where signifier and significance have an incommensurate relation to one another. The paradox is an economy in which the surplus value of labor produces scarcity, poverty, and inequality, without the possibility of its transformation. The promise of such a transformation would be a democracy of shared surplus between unalienated and equal subjects, a different economy of the body, the promise of a life beyond utility, nonproductive expenditure, the eroticism of the gift.[10]

Gonzalez-Torres works here through the concept of the gift. He reconceptualizes the "sexualization of the commodity and the commodification of sexuality" as played out by Pop art.[11] That is, he postulates an economy of

expenditure in which the unfulfilled promise of freedom is embodied in the very slippage between the desire to consume and consuming desire, a desire without calculation.

The Promise

From 1990 to the present, Gonzalez-Torres has made a series of sculptures out of sweets. Laid out in mounds, they are there for the taking. Another gift, memories of childhood and the pleasure of candy. One such mound was called *Untitled (USA Today)* (1991), reminding us of the headline news with its daily rush of sound bites like the rush of sugar and the promise of instant gratification, renewed each day.

In a number of "sweet" sculptures, the artist returned to the subject of the body. While one work represented the weight of his father, another was based on the body weight of the artist himself and his lover. The consumption of food not only portrays or betrays the character of someone, but also the body's dependence on blood sugar for both its energy and dispersal. Not only an eating away of the body, but a sign of regeneration, as in the symbolic eating of Christ's body and the miraculous giving of life.

The economy of the body can be likened to the character of the gift. As Lewis Hyde suggests in his book on the subject, "When you give a gift, there is momentum, and the weight shifts from body to body."[12] But then, too, in the economy of circulation around which Gonzalez-Torres produces his work, so does the work of art as art. Through consumption and reproduction, it undergoes permutation and change without reserve. Subject to constant circulation it remains always in excess of itself, slipping between a thing in itself and that for which it stands.

In *Untitled (Placebo)* (1991), the artist laid out in a rectangular form 1,000 pounds of glittering silver-wrappped candies. The title suggests not only the possibility of unqualified gratification, but equally the bittersweet

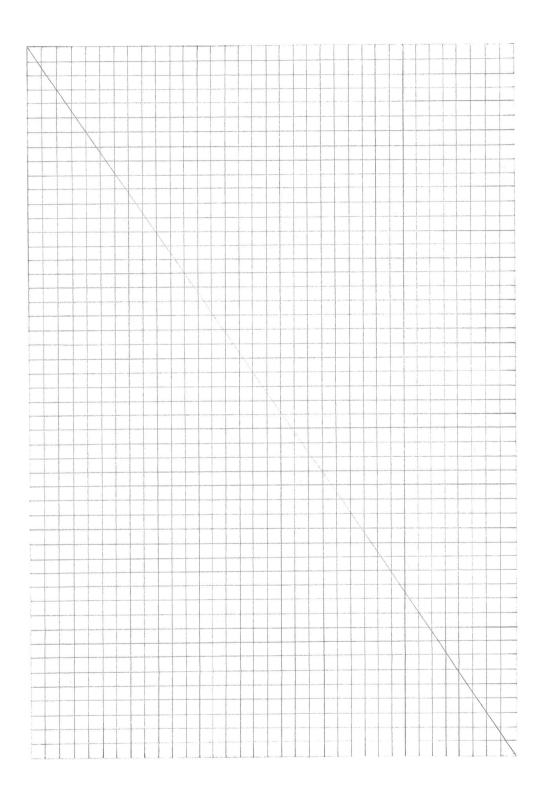

potential of duplicity and disappointment. Placebo can be defined also as "honeyed words . . . voice of the charmer, mouth-honor, lip-homage."[13] A gift indeed, but like the 'pharmakon,' always with the possibility of being other than what it appears, not a remedy, but rather a poison. In such work, Gonzalez-Torres addresses not only the commodification of sweets as the object of erotic investment, but the poignant irony of consuming desire.

Parenthetically

The operation of the parenthetical in the titles not only parodies the rhetorical masking of language in the public sphere, but discloses that which is suppressed. This doubling of title opens the boundaries of the public and private in order to reveal the presence of another scene, a secret filiation. It calls attention to an alternative reading, to the expression of one's own subjectivity and the right to difference.

The Line of Fortune

From 1988 on, Gonzalez-Torres has composed a series of drawings made of a single line running across a graph. In the earlier work the line ran upwards, and in the more recent down, as if charting the rise and fall of stocks, or sales of one commodity or another. The surplus value of labor, Marx might have called it, but the artist has chosen a different name, "Bloodwork." The wavering line is not the abstract sign of market value, but of a different economy of fortune. By appropriating a minimalism of style, Gonzalez-Torres was reproducing the clinical character of medical charts of the body's life. This was an economy of the body, with its line running upwards to indicate a healthy recovery, and down to mark its decline. And in reading such charts daily, so too the audience became its subject whose feeling of hope, of unho-

peable hope, rises and falls. Contemplation becomes affective, and knowledge is gained through the sensuousness of thought. I am reminded of Malevich's Suprematist drawings of 1915, straight lines soaring, seeking the liberated freedom of the sky, the space of the sacred, of transcendence from the earth-bound line of horizontality, the place of birth and death.

One to Another

Two strings of lights falling together to the floor in the corner faintly illuminate the two walls before us, each covered by an image of a bird flying across the sky. And in the opposite corner where they meet, darkness.

There was little or nothing else in the gallery. That was the point, nowhere to turn, except perhaps the cheerful laughter of those working behind the desk. Different expenditures, we might say, a kind of forgetting. An image of the sky, the dream of flying free, a bird soaring, free falling, drifting, solitary. And the falling lights, *Untitled (A Couple)* (1993), illuminating darkness. They are frail in their singularity, but in falling to the ground they intertwine, gathering together in a shock of illumination as if, in union, they provide light, an optimism, a source of strength and celebration.[14] The lights become a symbol for the erotic expenditure of energy without measure.

Days of giving gifts, of watching with delight how the gift opens the desire of the beloved. Gestures of generosity, of spirit, a kind of expenditure, a risky business perhaps, because it is always an unconditional loss. The work of art, like the giving of the gift, always requires an/other, its cir-

Untitled (Blue Curtains), 1991

culation demands an economy of sharing, a partition, a partner, and yet is always a departure, always a parting, a loss. Yet in marking the advent of giving as an openness towards the other, as a parting, it also serves to signal change. As in other work, the openness represents a refusal to foreclose meaning, and always the appeal for hope and desire for renewal.

Since 1991 Gonzalez-Torres has exhibited as work curtains installed against a window. As before there is a singularity of gesture, a minimum of signs. He leaves us with an image that assumes life through the movement of its flowing rhythms, billowing out and falling to rest, still, as if pausing before opening up again to the wind passing through. In *Untitled (For Ross)* (1989-92), the light radiates through the translucent blue curtains, shimmering across the floor to create an image of the sea moving before our gaze. A reflection, nothing more, and yet in filling the space, the curtains become a sensorial body; they offer themselves as in the giving of oneself to another.

Shortly after I began to write this essay, my friend Ian Burn died tragically while saving the life of a member of his family. I dedicate it to him.

My thanks go to Felix Gonzalez-Torres and Andrea Rosen for their generous and critical reading of an earlier draft and to the staff of Andrea Rosen Gallery for their assistance with materials and unending demands on their time.

[1] The sheets of Gonzalez-Torres constitute neither a part of the work nor a work of art in and of itself, except in kind. Rather the work exists first and foremost as a concept and only when in its complete and original form. And if the stack is already owned when exhibited, that which is shown represents a simulacrum of the original work.

[2] Marcel Mauss, *The Gift* (1925) (New York: W. W. Norton and Co., 1967).

[3] Jacques Derrida, *Given Time: 1. Counterfeit Money* (Chicago and London: University of Chicago Press, 1992), p. 17.

[4] Jacques Derrida, "Difference," in *Margins of Philosophy*, trans. Alan Bass (Chicago: University of Chicago Press, 1982), pp. 18-19.

[5] Anne Umland, "Projects 34: Felix Gonzalez-Torres" (New York: The Museum of Modern Art, 1992).

[6] Robert Nickas, "Felix Gonzalez-Torres: All the Time in the World," *Flash Art* 24, no. 161 (November/December 1991): 86.

[7] See David Deitcher, "How Do You Memorialize a Movement That Isn't Dead?" *The Village Voice* (June 27, 1989): 93.

[8] The exhibition "Cuarta pared," curated by Jesus Fuenmayor, will inaugurate El Museo del Oeste in March 1994.

[9] See the critique of Minimalism by Anna C. Chave, "Minimalism and the Rhetoric of Power," *Arts Magazine* 64, no. 5 (January 1990): 44-63.

[10] These questions are explored in Georges Bataille, *The Accursed Share: An Essay on General Economy* (New York: Zone Books, 1991).

[11] Benjamin H. D. Buchloh, "Andy Warhol's One-Dimensional Art: 1956-1966," in *Andy Warhol: A Retrospective*, ed. Kynaston McShine (New York: The Museum of Modern Art, 1989), p. 51.

[12] Lewis Hyde, *The Gift* (New York: Vintage Books, 1983), p. 9.

[13] *Roget's Thesaurus of Words and Phrases* (New York: Perigee Books, 1989).

[14] At the same time that this work was shown in the front room of Andrea Rosen Gallery, the series *Untitled (Bloodwork—Steady Decline)* (1993) was shown in the back. See also the sensitive review of the exhibition by Terry R. Myers in *Lapiz* (Summer 1993), p.84.

Illustrations

All works courtesy of the artist and Andrea Rosen Gallery, New York, and all photographs by Peter Muscato unless otherwise indicated.

Selected Bibliography

Avgikos, Jan. "This Is My Body: Felix Gonzalez-Torres." *Artforum* 29, no. 6 (February 1991): 79-83.

Bartman, William S., ed. *Felix Gonzalez-Torres.* Los Angeles: A.R.T. Press, 1993. Essay by Susan Cahan, short story by Jan Avgikos, and interview with the artist by Tim Rollins.

Berlin, RealismusStudio der Neue Gesellschaft für Bildende Kunst, and Kassel, Museum Fridericianum. *Cady Noland/Félix González-Torres: Objekte, Installationen, Wandarbeiten.* 1990. Essays by Frank Wagner, Jan Avgikos, Kirby Gookin, David Deitcher, and a "text collage" by Robert Nickas.

Deitcher, David. "How Do You Memorialize a Movement That Isn't Dead?" *The Village Voice* 33, no. 26 (June 27, 1989): 93.

Ferguson, Russell, Martha Gever, Trinh T. Minh-ha, and Cornel West, eds. *Out There: Marginalization and Contemporary Cultures.* New York: The New Museum of Contemporary Art and M.I.T. Press, 1990. Images selected by Felix Gonzalez-Torres.

Myers, Terry R. "Felix Gonzalez-Torres." *Lapiz* 11, no. 94 (Summer 1993): 84.

Milan, Massimo De Carlo Gallery. *Felix Gonzalez-Torres.* 1991. Essay by Steven Evans.

New York, The Museum of Modern Art. *Projects 34: Felix Gonzalez-Torres.* 1992. Essay by Anne Umland.

Nickas, Robert. "Felix Gonzalez-Torres: All the Time in the World." *Flash Art* 24, no. 161 (November/December 1991): 86-89. Interview with the artist.

Parkett, no. 39 (Winter 1994). Special issue on Felix Gonzalez-Torres, with essays by Nancy Spector, Susan Tallman, and Simon Watney.

Spector, Nancy. "Félix González-Torres." *Galeries*, no. 42 (April/May 1991): 80-81.

Stockholm, Magasin 3 Stockholm Konsthall. *Felix Gonzalez-Torres.* 1992. Essay by David Deitcher.

Tallman, Susan. "The Ethos of the Edition: The Stacks of Felix Gonzalez-Torres." *Arts Magazine* 66, no. 1 (September 1991): 13-14.

Vancouver, Fine Arts Gallery, The University of British Columbia. *Strange Ways Here We Come: Felix Gonzalez-Torres/Donald Moffett.* 1990. Essay by Scott Watson.

Wye, Deborah. "'Untitled (Death by Gun)' by Félix González-Torres." *The Print Collector's Newsletter* 22, no. 4 (September-October 1991): 118-119.

Felix Gonzalez-Torres would like to express his thanks to the following people: Wendy Brandow, John Campbell, Amada Cruz, Susanne Ghez, Ann Goldstein, Russell Ferguson, Steve Henry, Sylvia Hohri, Margo Leavin, Stacia Payne, Michelle Reyes, and, especially, Andrea Rosen.

This book accompanies an exhibition organized by Amada Cruz, Susanne Ghez, and Ann Goldstein, presented at The Museum of Contemporary Art, Los Angeles, April 24 – June 19, 1994, at the Hirshhorn Museum and Sculpture Garden, Smithsonian Institution, Washington, D.C., June 16 – September 11, 1994, and at The Renaissance Society at The University of Chicago, September 25 – November 6, 1994.

Presentation of this exhibition at all three venues has been made possible by a generous grant from Lannan Foundation.

Editor: Russell Ferguson
Assistant Editors: Sherri Schottlaender and John Alan Farmer
Design: John Campbell and Pamela Racs,
 Campbell and Associates Design, Pasadena, California
Printed by Typecraft, Inc., Pasadena, California

ISBN 0-914357-35-2